Acknowledgements

We would like to thank our loyal staff: Karen McDiarmid, Becky Ferguson, Bruce Montagne, Kirt Manecke, Sandy Higgins, and Erick Whitford for their contributions in the creation of this book; Thanks to Greg Dunn for his artistic contribution.

Publisher
Carl R. Sams II Photography, Inc.
361 Whispering Pines
Milford, MI 48380
800/552-1867 248/685-2422 Fax 248/685-1643
www.strangerinthewoods.com www.carlsams.com

Karen McDiarmid — Art Director

Sams, Carl R.
Loons in the Mist
by Carl R. Sams II & Jean Stoick, Milford, MI
Carl R. Sams II Photography, Inc. © 2013

Summary: A photographic journey of five summers with a family of common loons.

Printed and bound June 2013 — #84853
Friesens of Altona, Manitoba, Canada

ISBN 978-0-9827625-3-0

Loons (Common Loon)
Library of Congress Control Number: 2013939749

10 9 8 7 6 5 4 3 2 1

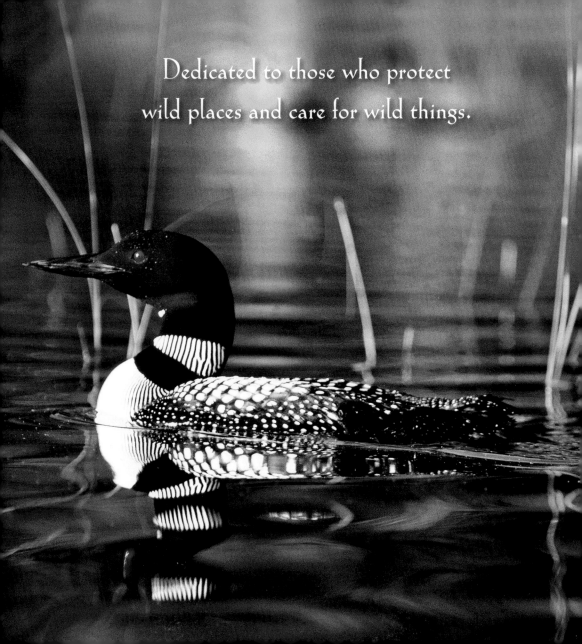

Dedicated to those who protect
wild places and care for wild things.

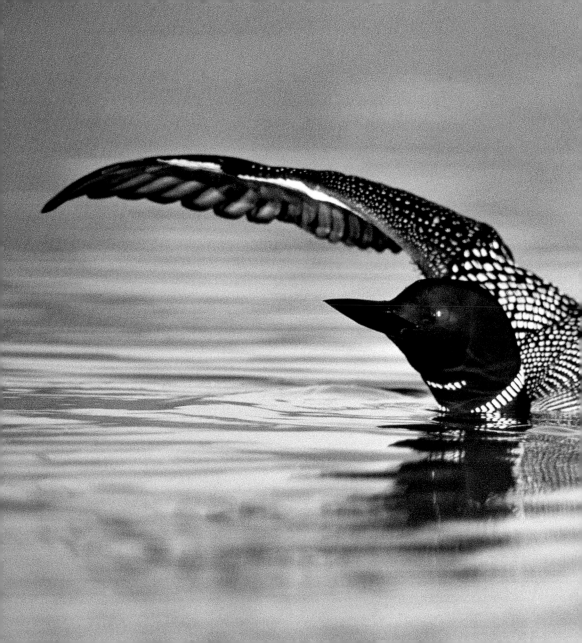

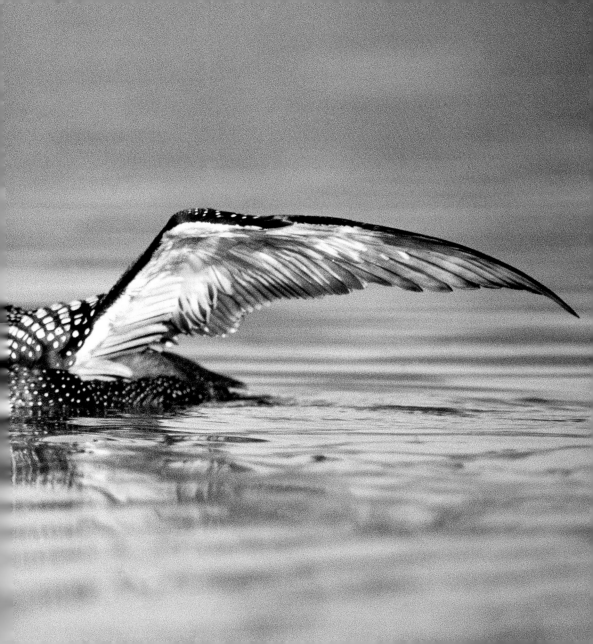

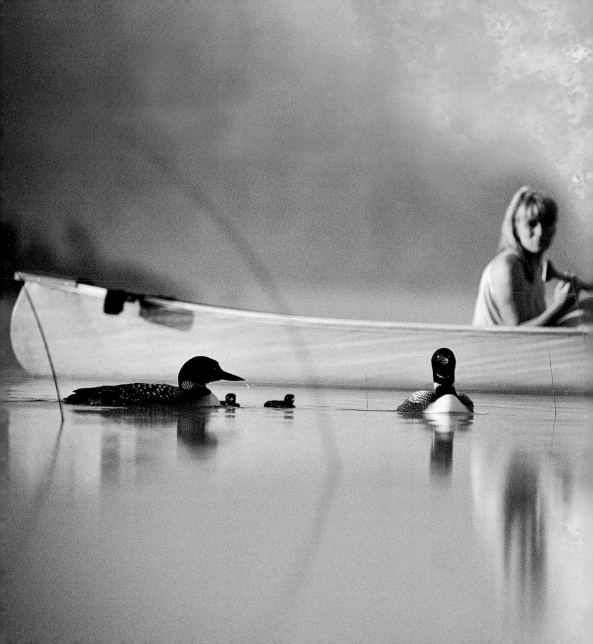

Quietly we pushed our canoe off shore through thick fog, following the call of the loons. Some mornings our search would take more than an hour before they appeared out of the mist like dark shadows.

Curiously, this pair of loons accepted our silently moving craft and gave us a rare opportunity to see their two newborn chicks. We spent the next five summers at this secluded lake recording the loons' behaviors.

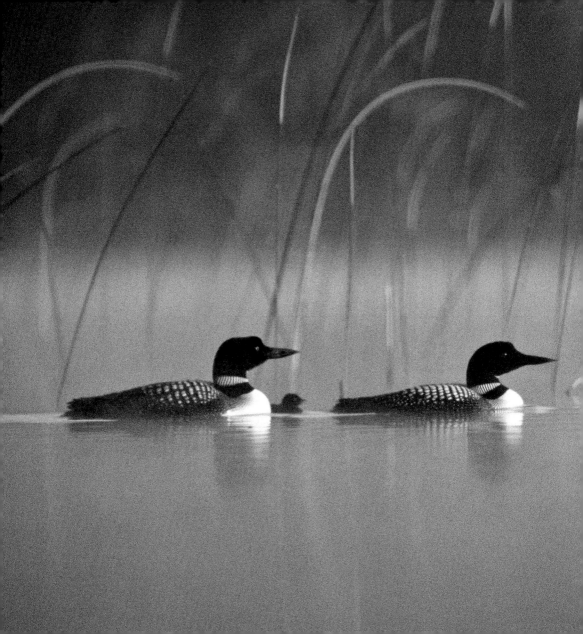

We were totally captivated
by the spirit of the northern lakes.

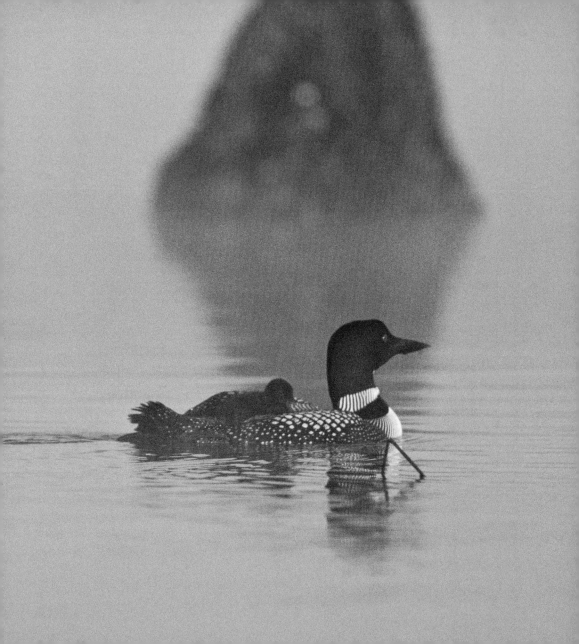

Each spring we spent two weeks slowly acclimating the loons to the presence of our floating blind. It was disguised to look like the mud and sticks of a muskrat-hutch. By the time the chicks were ready to hatch, the loons paid little attention to us.

Most loons will not tolerate boaters and become very stressed when approached.

Fishermen have told us how they witnessed the
unique mating dance of the loon. Loons, however,
do not perform this kind of a mating display and
what they are describing is the "penguin dance"
which is a sign of extreme distress.
This behavior is caused by a
threat of another loon,
a predator,
or people
who have
approached
the loons
too closely.

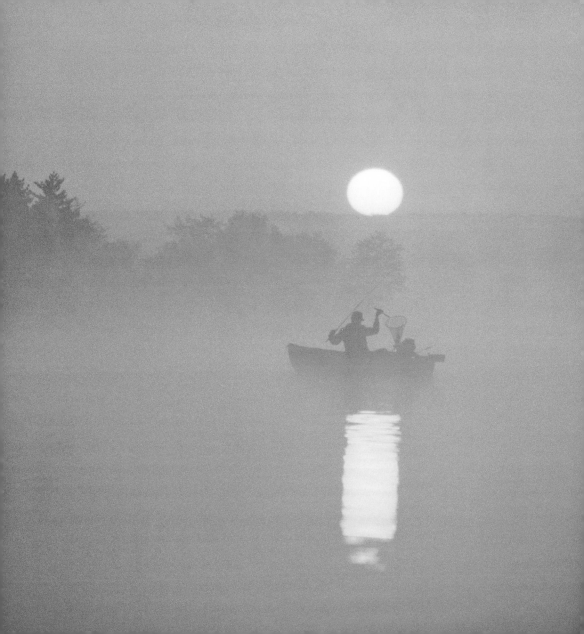

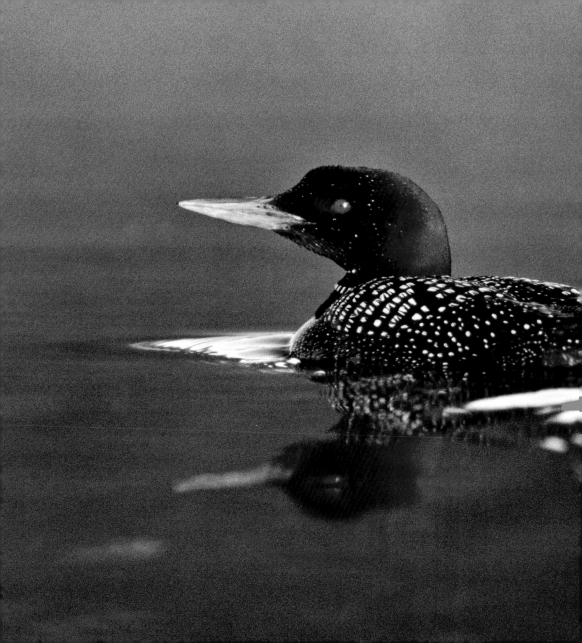

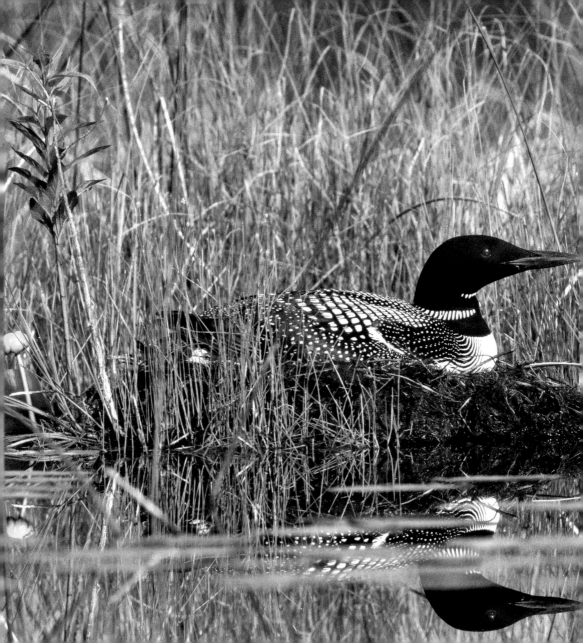

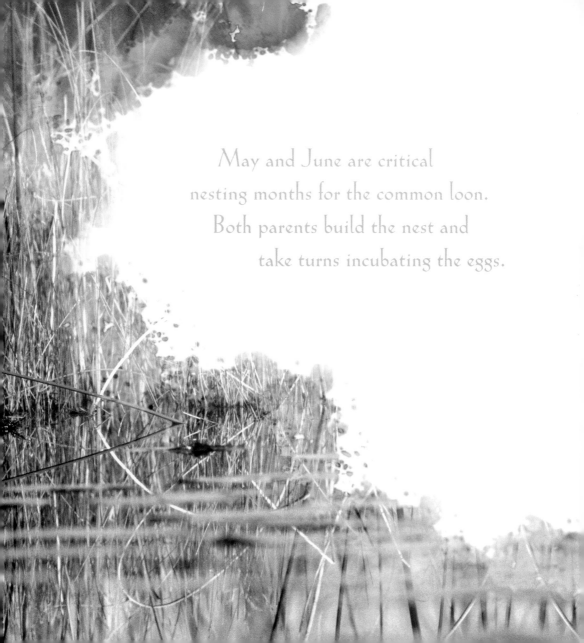

May and June are critical
nesting months for the common loon.
Both parents build the nest and
take turns incubating the eggs.

Watercrafts during weekends and summer holidays can keep loons off nests for long periods leaving eggs unprotected from the elements and predators.

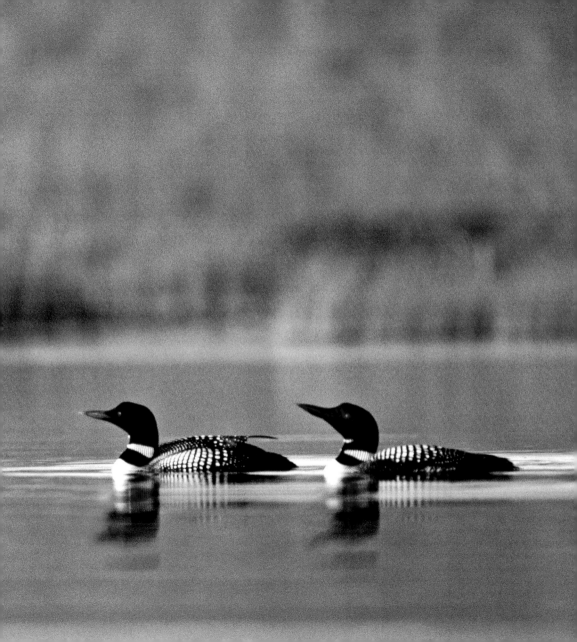

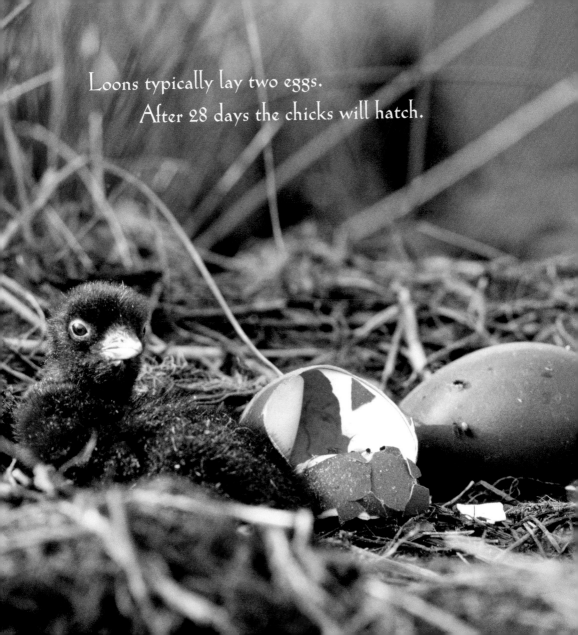

Loons typically lay two eggs.
After 28 days the chicks will hatch.

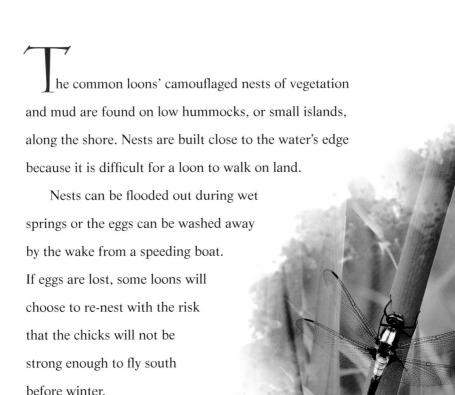

The common loons' camouflaged nests of vegetation and mud are found on low hummocks, or small islands, along the shore. Nests are built close to the water's edge because it is difficult for a loon to walk on land.

Nests can be flooded out during wet springs or the eggs can be washed away by the wake from a speeding boat. If eggs are lost, some loons will choose to re-nest with the risk that the chicks will not be strong enough to fly south before winter.

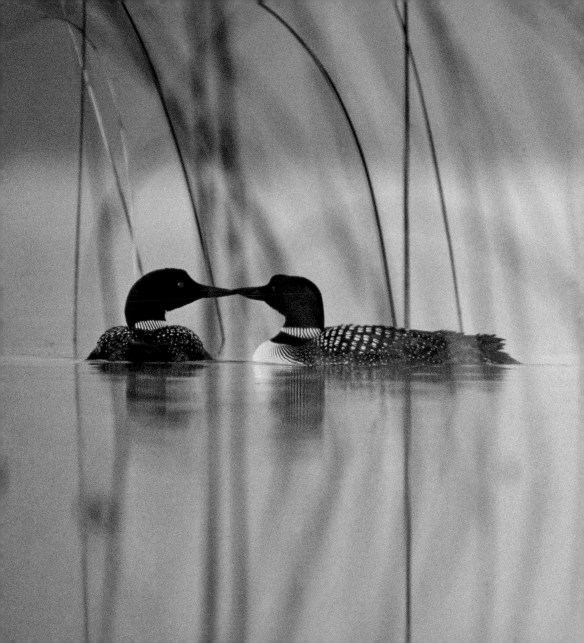

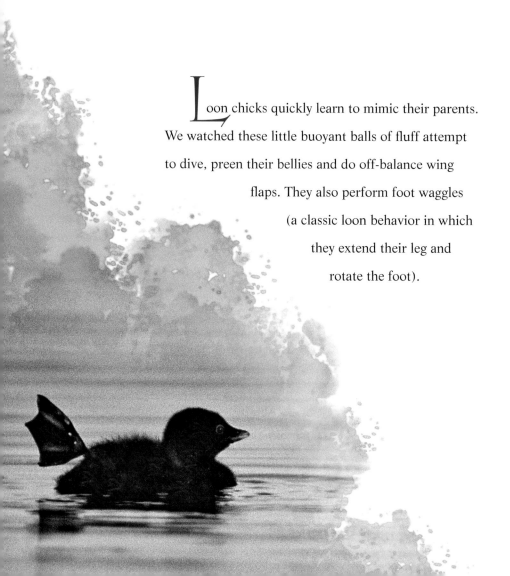

Loon chicks quickly learn to mimic their parents.
We watched these little buoyant balls of fluff attempt
to dive, preen their bellies and do off-balance wing
flaps. They also perform foot waggles
(a classic loon behavior in which
they extend their leg and
rotate the foot).

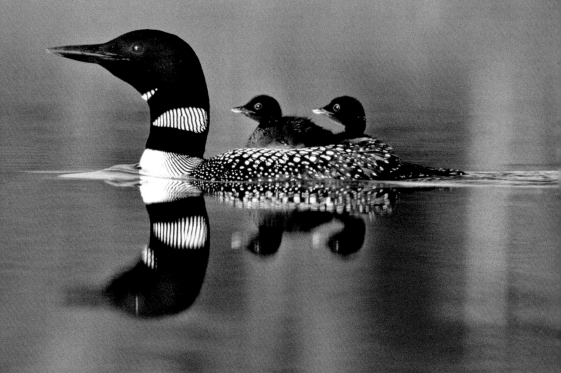

Loon chicks spend much of their first two weeks riding
on their parents' backs — a safe place for them.

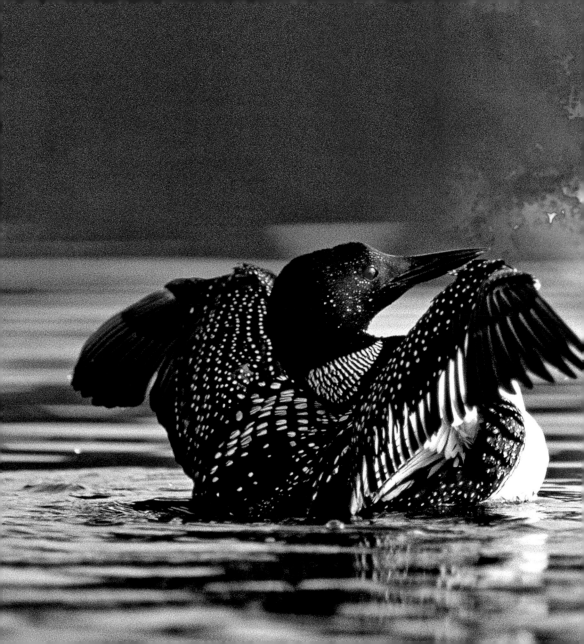

Loons routinely perform the "wing flap"
to shake water from their wings after diving
and as a sign of greeting to one another when a
mate returns to the lake.

Parents fish continuously to satisfy the chicks' ferocious appetite. A typical meal for small chicks is minnows. As they grow, the menu also includes perch, bluegill and crayfish.

Both parents share the responsibility
of caring for the chicks.

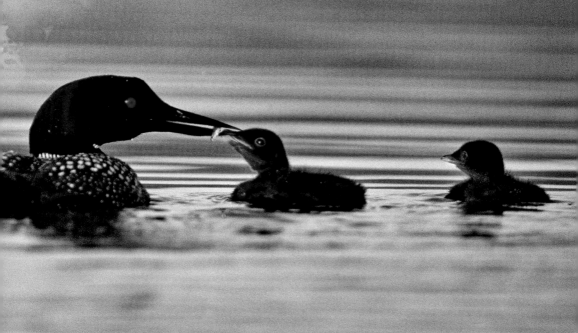

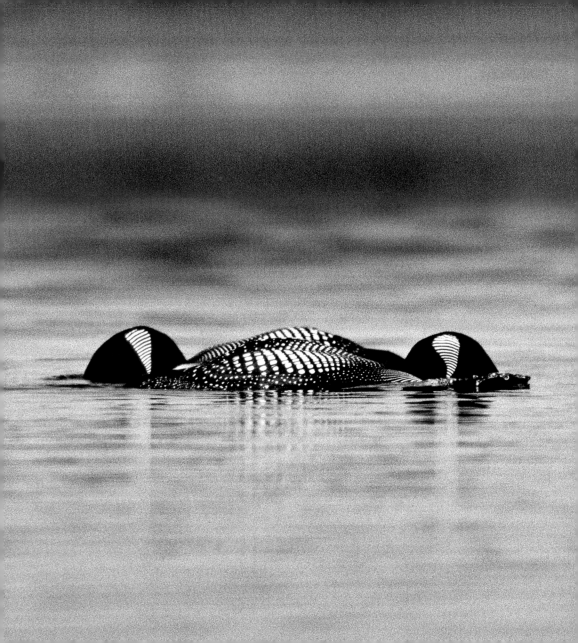

Chicks often periscope and follow along as their
parents fish. We saw them aggressively lash their
beaks across the neck of the parents urging
them to fish faster. During a single
morning, we counted as our chicks
were fed more than fifty
minnows and a crayfish.
One chick was still able to
down a large sunfish.

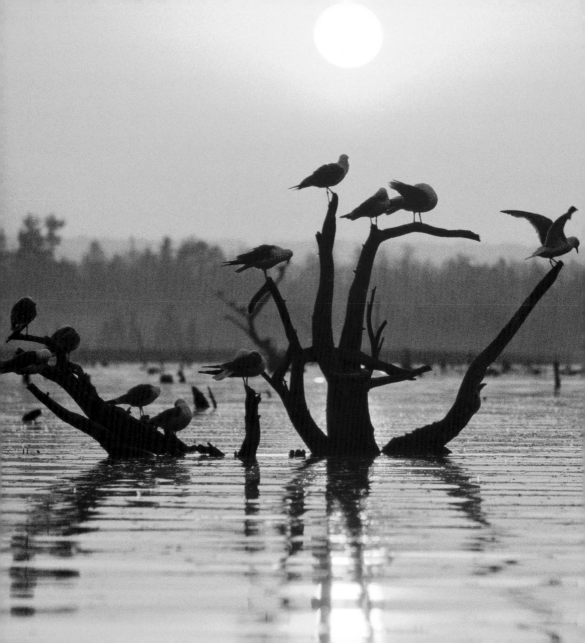

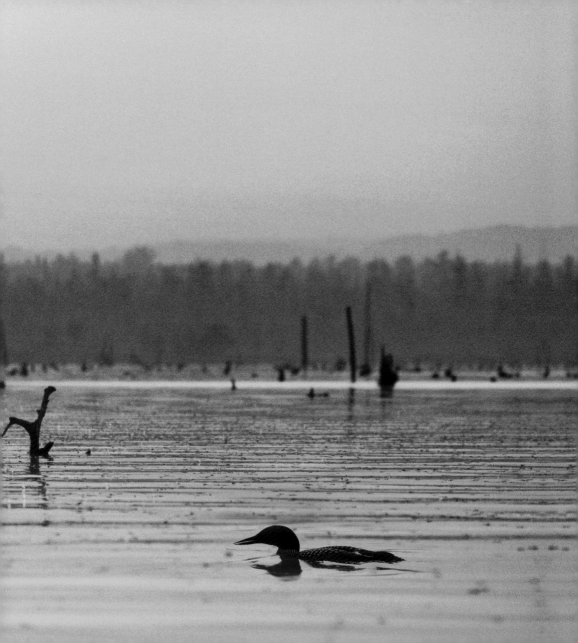

Adult male loons are generally larger than females,
but their markings are visually indistinguishable.

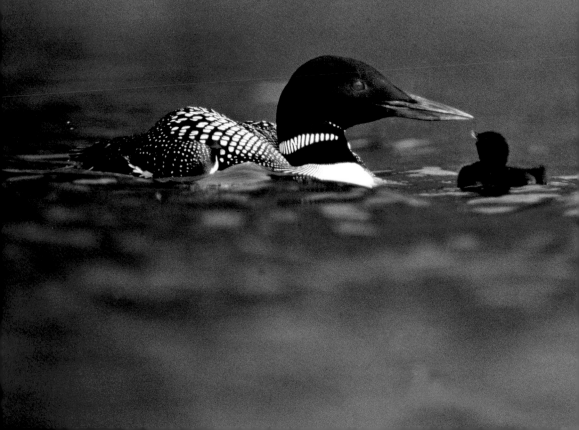

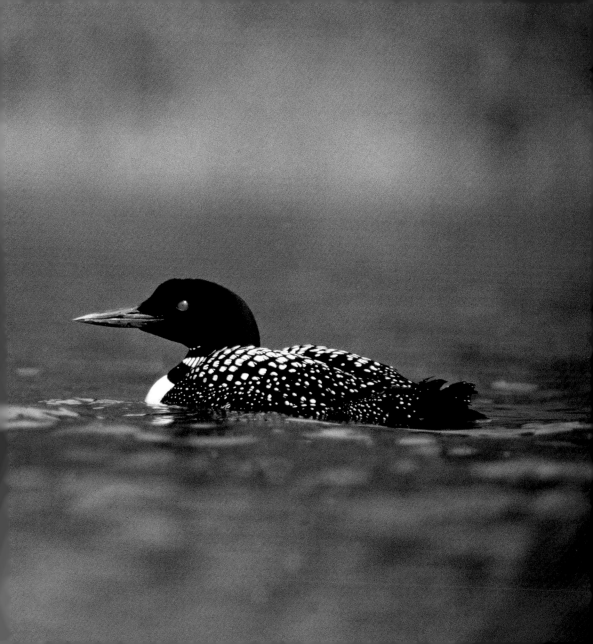

Unlike most birds, loons have solid bones.
This helps them dive deep but makes it difficult
to lift off the water when taking flight.

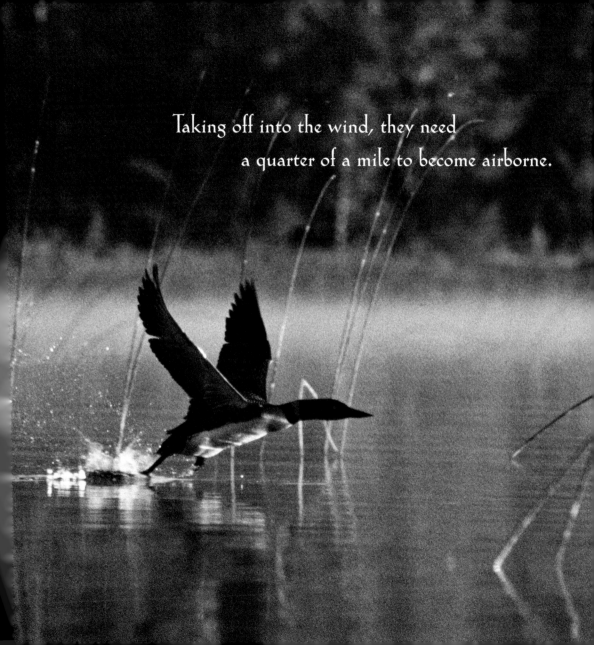

Taking off into the wind, they need
a quarter of a mile to become airborne.

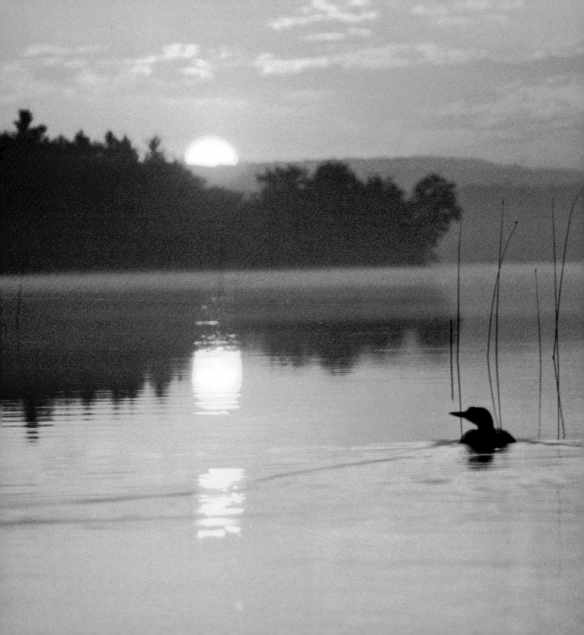

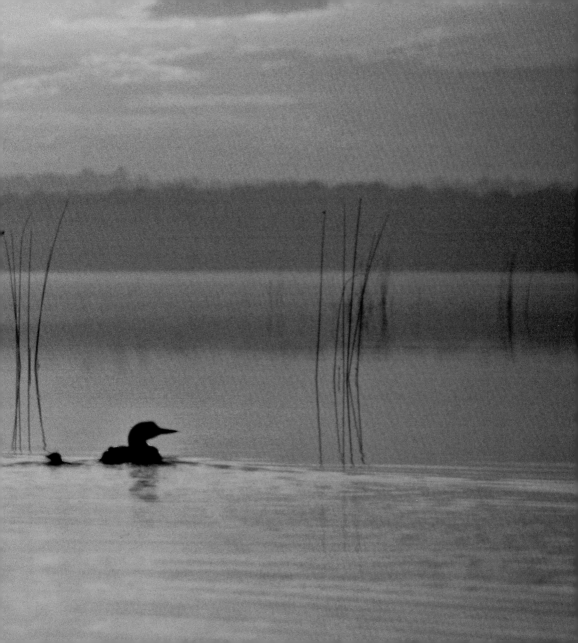

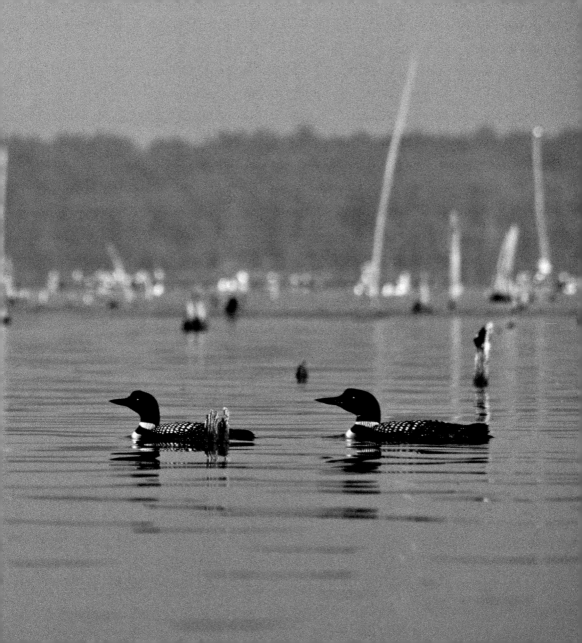

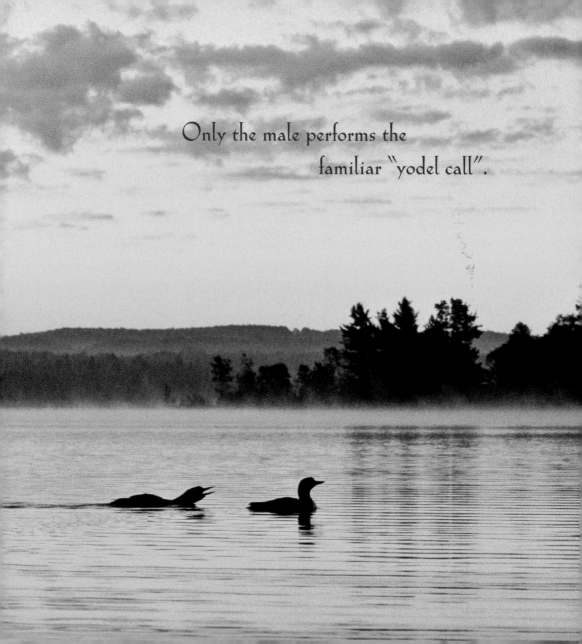

Only the male performs the
familiar "yodel call".

Loons are territorial and defend their boundaries with intimidating displays and aggressive contact if necessary.

Our male would lay flat with his neck stretched across the water to perform a series of yodel calls warning any loon about to enter his territory. This signal alerted us to scan the horizon. Within 20 seconds, a loon would come into view.

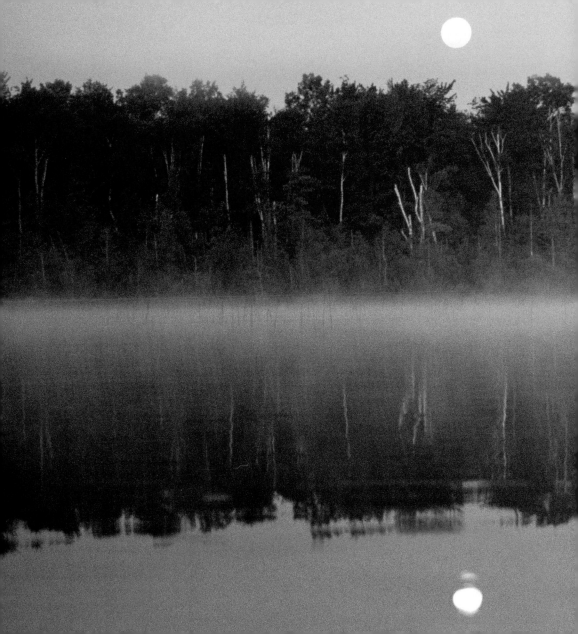

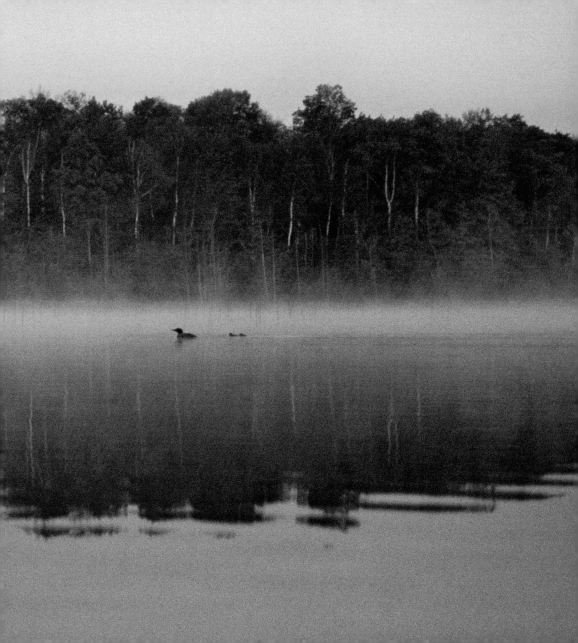

Our pair would quickly confront any loons bold
enough to land. They would circle the invading
rogue loon with bills tucked in a threatening
posture. After faking several dives
they would suddenly plunge
beneath the surface. Fearful
of being speared, the
trespasser would fly
off. One or both of the
parents would follow
in pursuit to chase the
invader out of
their territory.

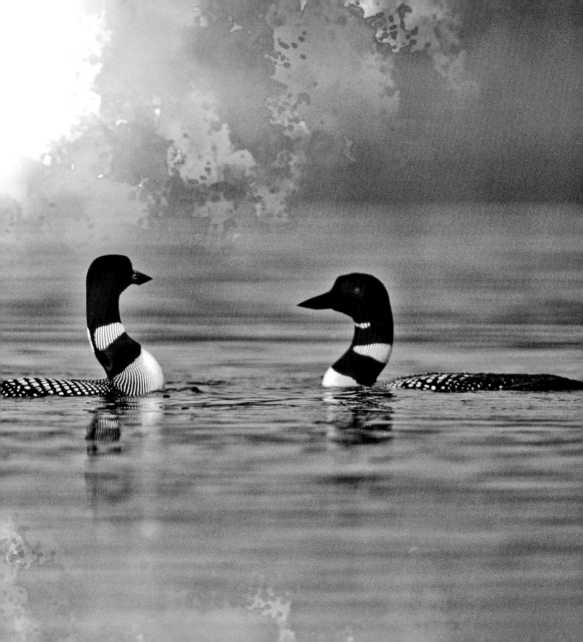

When there's trouble,
the chicks lay flat in the water

attempting to go unnoticed.

One summer day, we witnessed a rare confrontation between our pair of loons and a very aggressive rogue loon.

A violent thunderstorm kept us off the lake until evening. As we set our canoe into the water, we spotted two loons heading toward the far end of the lake. A fierce fight broke out. Splashing wildly, they tumbled across the water's surface with flailing wings.

The fighting loons dove under the water and after a long interval, only one loon surfaced and quietly swam away.

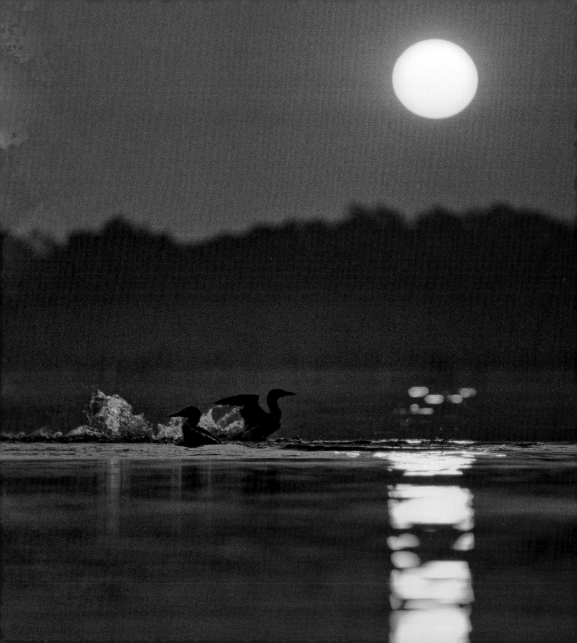

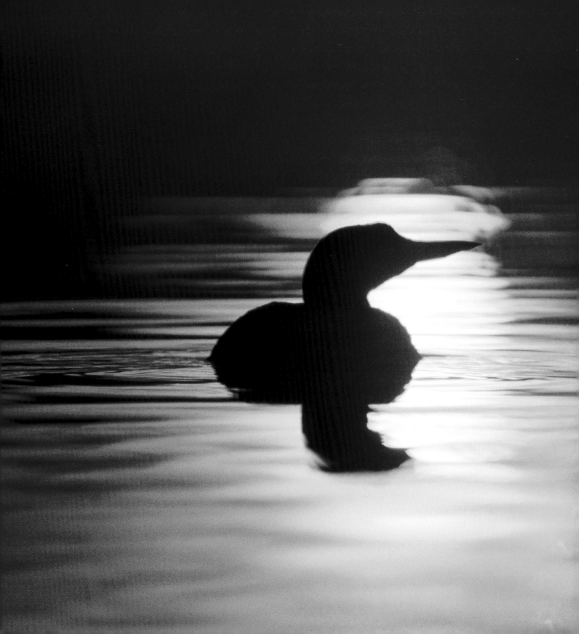

Out of nowhere, a single
frightened chick, followed by its
mother, swam toward the safety of our
canoe. We were apprehensive as we did
not see her mate or her other chick.
We paddled around the lake searching
for the mother loon's mate and
the missing chick. As darkness
approached, we called off our search.

Early the next morning we pushed our canoe off into a dense, thick fog and found the mother loon feeding a chick.

A second adult loon swam out of the mist. A violent fight erupted and both loons dove. When they surfaced, the mother loon grasped the other's wing in her beak.

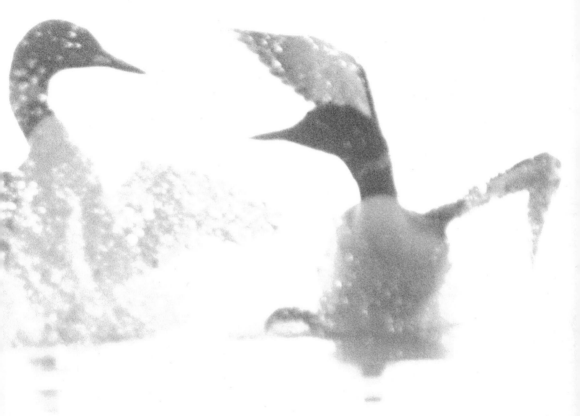

In this uncommon physical confrontation,
the chick watched helplessly as the parent
tried to drive off the "rogue loon".

The rogue loon broke free and lunged, snatching the frightened chick. He violently shook it and held it under the water. The desperate mother speared the invader freeing her chick and continued her attack. She was finally able to drive him off as the helpless chick struggled toward shore.

The mother called softly urging the injured chick to follow. Unable to lift its head, the chick lay motionless, face-down in the water, drowning.

We didn't want to interfere, but felt the chick's only chance for survival was to find help. We wrapped the baby loon in a sweatshirt and took him to a local veterinarian.

Finally, the female gave up on her injured chick
and silently swam away, disappearing into the fog.

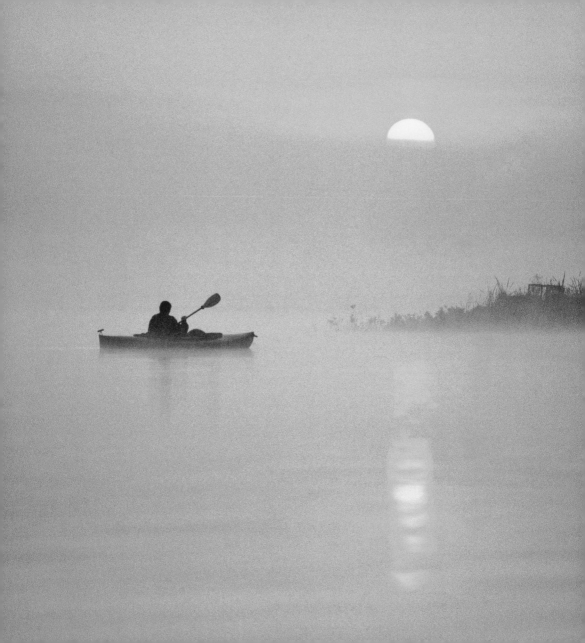

Leaving the chick with the vet, we returned to the lake to look for the missing male and second chick. Despite three hours of searching, we could not find them.

When we returned to check on the chick's progress he had perked up and his lungs were clear. He accepted several minnows in the aquarium we had set up. It was agreed that he was ready to be returned to the lake.

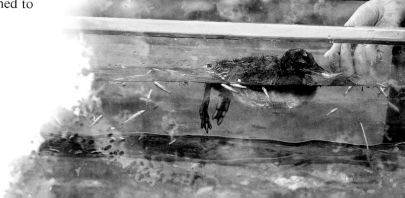

With the chick safely stowed in our canoe, we
pushed off shore to search for its mother. After scouting
for several hours we did not see a single loon. Finally,
at dusk, we spotted an adult. We were not sure if it was
the parent or the rogue. As we approached, the loon
continued to dive and swim away.

Eventually, we got close enough and held
the chick out toward the loon. He
peeped loudly and the adult
quickly turned and
called back in response.
"Could this be his
mother?" we wondered.

We placed the chick in the water
and held our breath as the two came together.

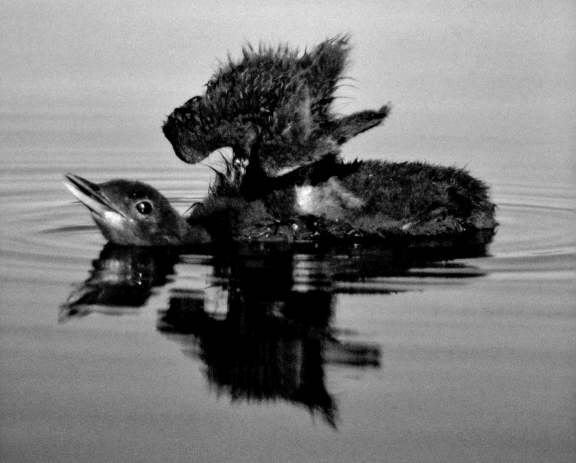

To our delight, they greeted each other
with a familiar wing flap.

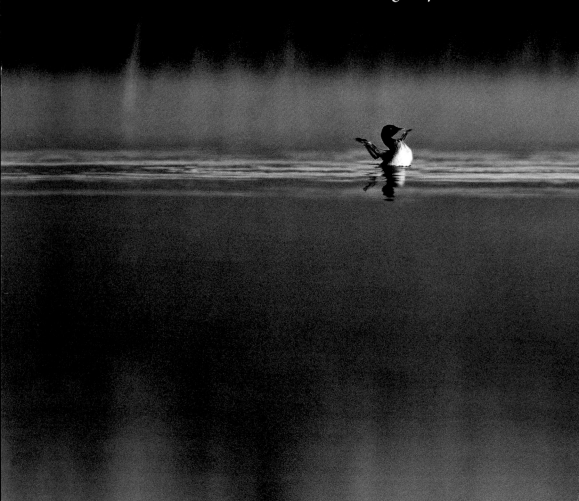

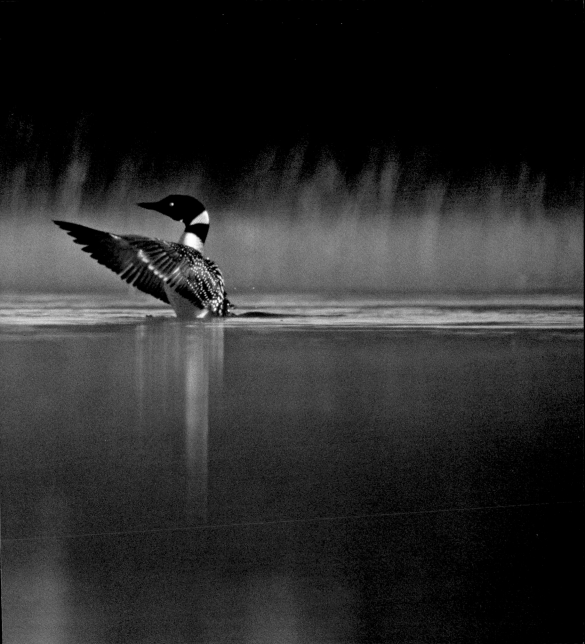

She swam off with her chick on board,
glancing back at us one last time.

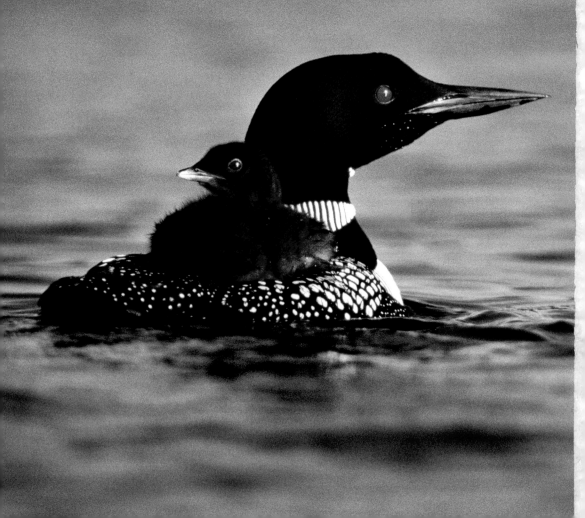

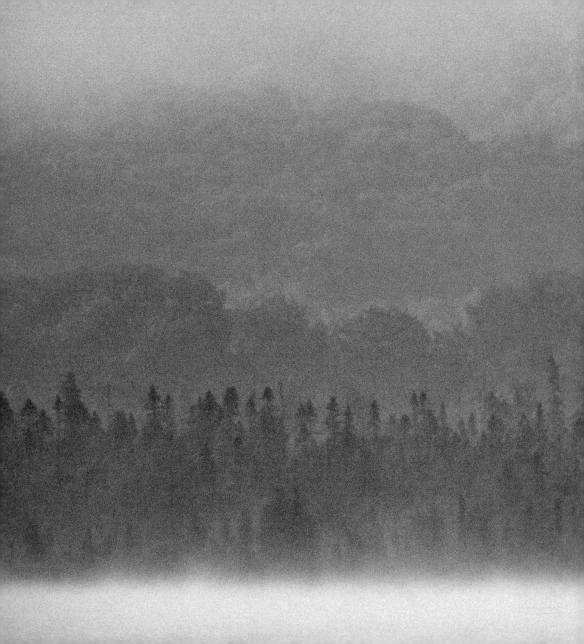